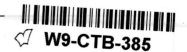

Simon and the wind

Gilles Tibo

Tundra Books

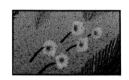

My name is Simon and I love the wind.

When the autumn wind begins to blow
I go out to watch things fly.

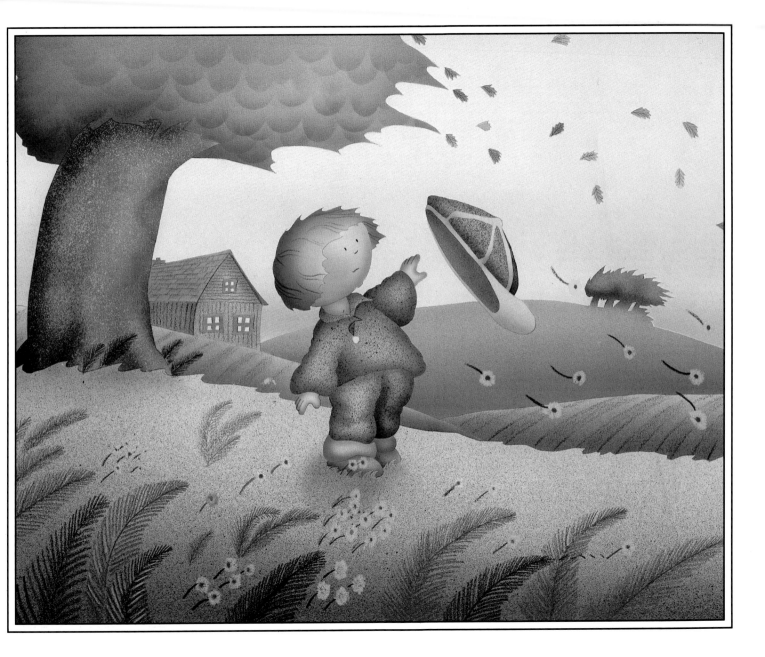

I stand on a rock and blow soap bubbles.
The wind carries them off and away.

If I could blow a big enough bubble,
Would it take me flying in the wind?

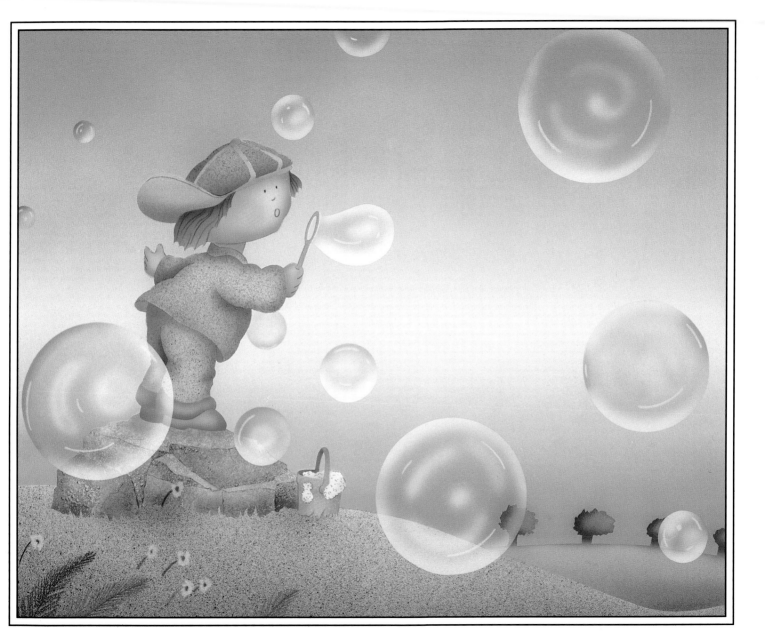

I run to catch my biggest bubble
But it blows into a tree and breaks.

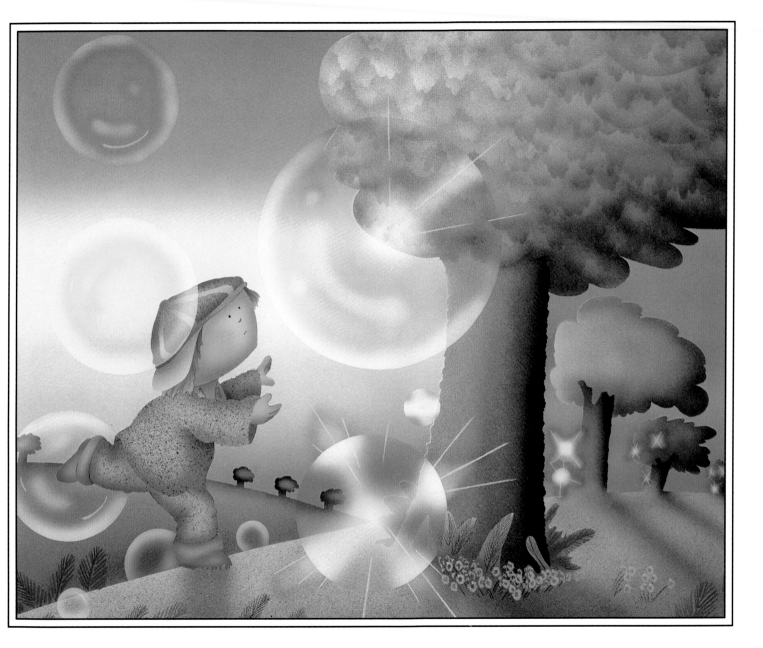

I go to a garden to ask the scarecrow:
"How can I learn to fly in the wind?"

"It must be easy, Simon," said the scarecrow.
"Even the birds know how to do it."

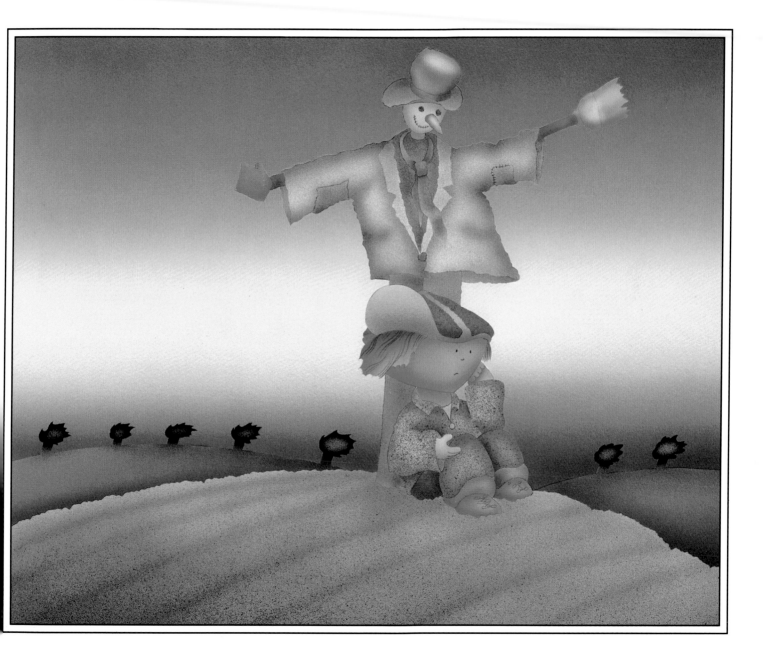

I go to the river to meet the birds.

My friend Marlene brings an airplane.
I talk to the birds and ask them:
"Will you pull us in the wind?"

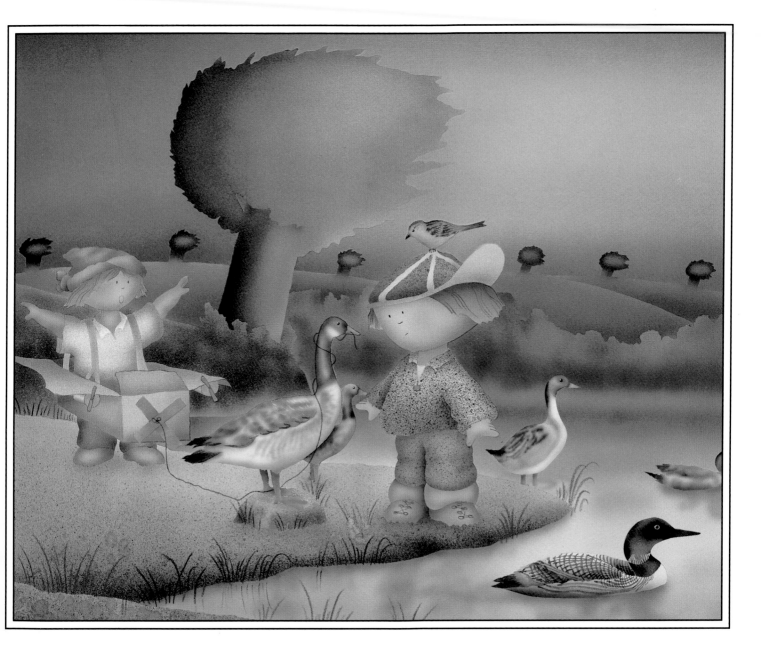

But the birds are flying far away,
And don't know when they will return.

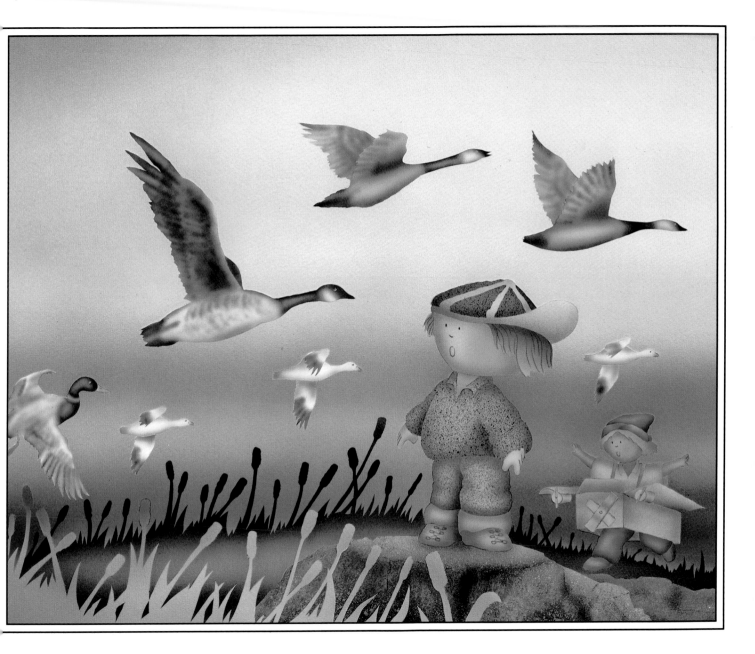

I lie on the grass and ask the sun:
"How can I learn to fly in the wind?"

"It must be easy, Simon," said the sun.
"Even the clouds know how to do it."

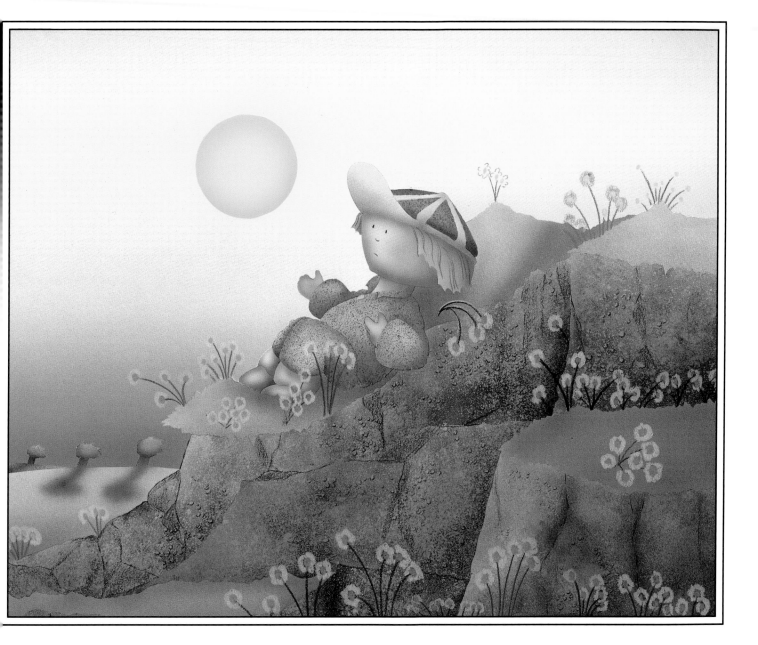

I ride up a mountain to talk to the clouds.

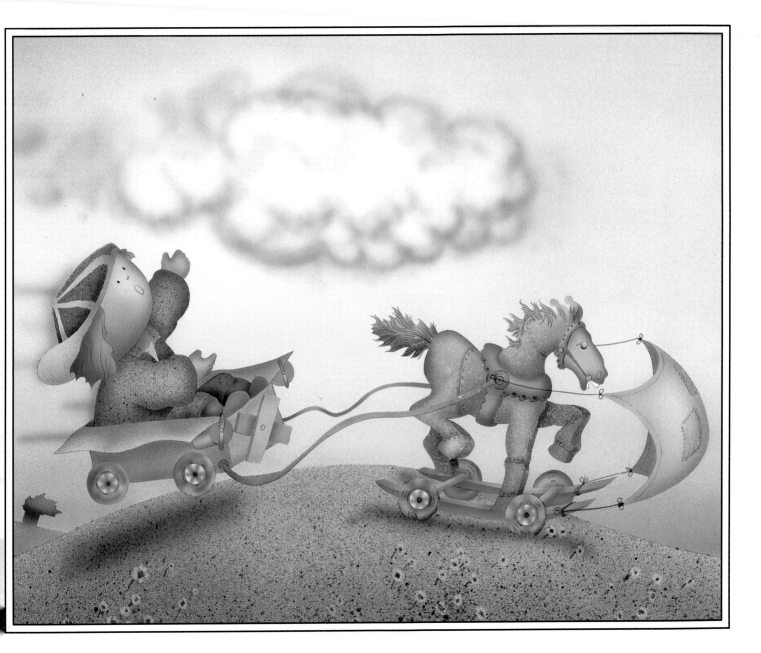

But the clouds turn to rain
And I must run home.

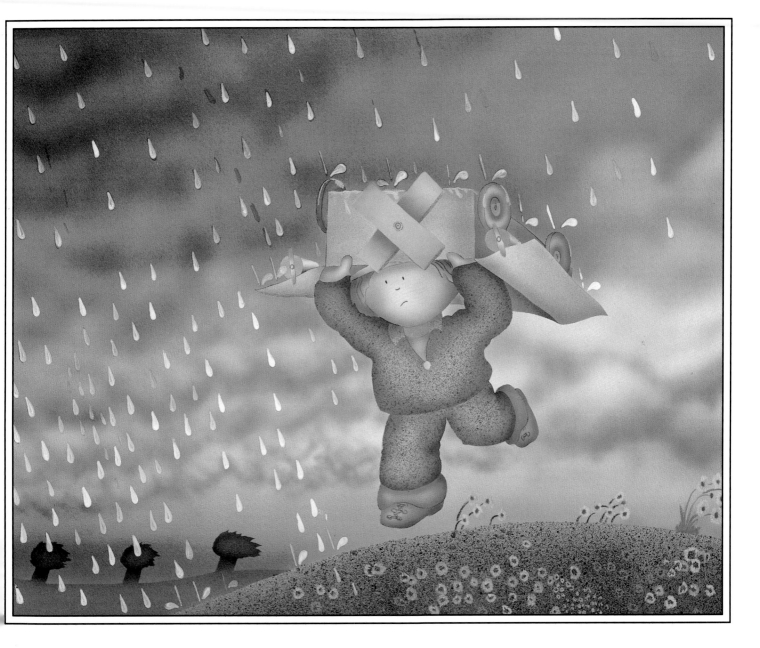

I go to a field to look for my friends.

I cannot fly in the wind like a bubble,
or like the birds
or like the clouds.

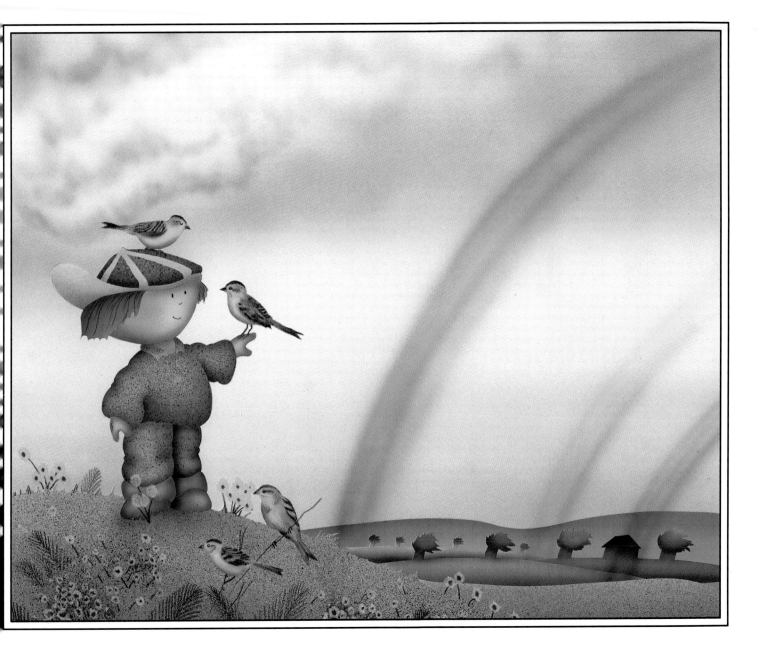

But I can make other things fly.

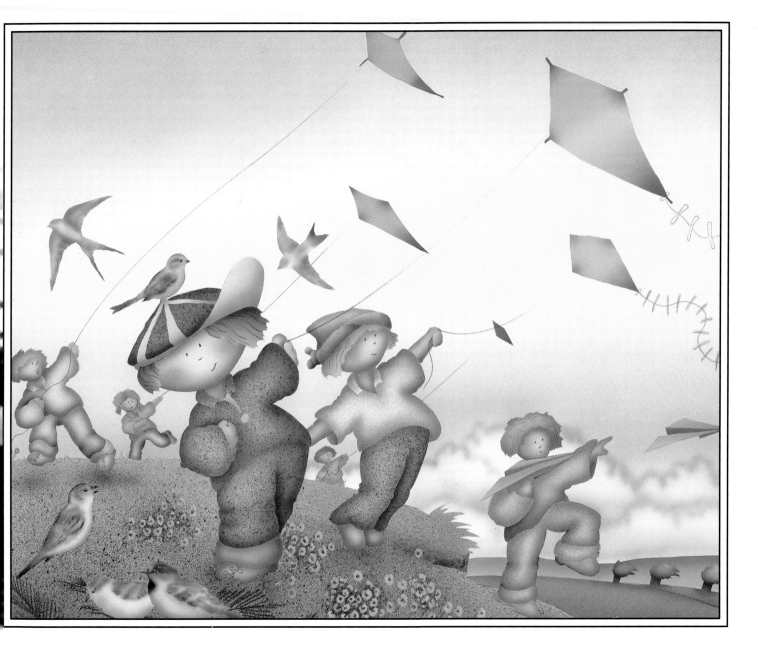

To Ariane

© **1989 by Gilles Tibo**

First Paperback Edition, 1991

Published in Canada by Tundra Books, 481 University Avenue, Toronto, Ontario M5G 2E9
Published in the United States by Tundra Books of Northern New York, P.O. Box 1030, Plattsburgh, New York 12901

Library of Congress Catalog Number: 89-50777

National Library of Canada Cataloguing in Publication Data
Tibo, Gilles, 1951–
[Simon et le vent d'automne. English]
 Simon and the wind

Translation of: Simon et le vent d'automne.
For children aged 3-6.
ISBN 0-88776-276-X

 I. Title. II. Title: Simon et le vent d'automne. English.

PS8589.I26S53813 1999 jC843'.54 C99-930294-9
PZ7.T52Si 1999

We acknowledge the support of the Canada Council for the Arts for our publishing program.

We acknowledge the financial support of the Government of Canada through the Book Publishing Industry Development Program for our publishing activities.

Printed in Hong Kong

7 8 9 10 11 06 05 04 03 02